# A Way of Life

# A Way of Life
## Notes on Ballenberg

Edited by Rolf Fehlbaum

Jasper Morrison
David Saik
Tsuyoshi Tane
Federica Zanco

With a contribution by
Beatrice Tobler

Lars Müller Publishers

Ballenberg?

Like most Swiss I had a notion of Ballenberg, an open-air museum in central Switzerland with a collection of rural buildings from all Swiss regions. I associated Ballenberg with Heimat, folklore, Swiss flags and geraniums on balconies, a combination I was not keen on.

I have been working with architects and designers and visiting architectural sites all my professional life, but it was not until I had reached the age of 78 that I finally visited Ballenberg.

Federica Zanco and I made the trip to Ballenberg with few expectations. We entered the site, visited the first building, an eighteenth-century chapel, and then proceeded up a hill to the mills of the canton of Valais.

We could not believe what we saw: buildings from different regions of the country in an extraordinarily beautiful setting. That was the first impression. From up close, we started examining windows, stairs, doors, handles, roofs – and were enthralled. They were thoroughly functional, of course, as there is no room for anything arbitrary in a rural context, but within this framework of practical problem solving, there was often beauty and joy. "Look at this construction, look at that decoration, see this detail, how clever that solution is …" We were in a frenzy of discovery.

7

Federica took pictures with her phone. We wanted to show what we saw to our friends. How can we have waited so long to make the trip and why did most of our Swiss friends only have a vague idea of Ballenberg and why was practically no one outside of Switzerland aware of it? Federica sent her photos of doors, stairs, floors, chimneys, kitchens and buildings to our friend Jasper Morrison, with whom I had worked at Vitra for decades. He would understand. He came over from London to visit Ballenberg and was equally enthusiastic. We came up with the idea of making a book about Ballenberg for people with similar interests, a book that would invite the study of things we ordinarily overlook, things that prove at second glance to be beautifully appropriate, a book on How to See.

We approached the publisher Lars Müller, whose unique books on design and architecture can be found in bookstores from Helsinki to Kyoto. His initial assessment of the potential was doubtful, but he was interested and willing to advise us. How should we handle the photographs, how should we express our observations? Our individual reactions in words and pictures would be a feature of the book.

Federica with her sharp eye and lively, spontaneous photographs set the tone. Short written observations would complement the images. In this spirit Jasper Morrison would take pictures and add his comments. He invited David Saik, a Canadian architect friend based in Berlin, to do the same. Around this time I was working with the Japanese architect Tsuyoshi Tane on a project for the Vitra Campus.

I urged him to visit Ballenberg and he returned with photos that we all liked a lot. So he joined the team.

These are architects and designers who have developed a sense of essentials in and through their work and this served them well in their discovery of Ballenberg.

The management of Ballenberg welcomed the project, and Beatrice Tobler, until recently head of research at the museum, supported us with her expertise in all phases.

Why did we find Ballenberg so fascinating and what would be the message of our book? The picturesque atmosphere has been well-documented in other publications. It was the appropriateness of these buildings and their interiors that caught our eye. No attempts to be original, no quest for style, no desire to impress, no invention for the sake of novelty but clearly out of necessity. Buildings that respond to specific needs and resources, accepting constraints as a matter of course. And yet, the result is not an architecture of sad, subsistence-level functionality but a genuine expression of work well done.

Constraints have shaped the Ballenberg world. Material constraints: using what is locally available and reacting to the climatic conditions has resulted in different idioms for each region in Switzerland. The way the buildings are set in the landscape reflects intelligent interaction with sun and wind, rain and snow. Economic constraints exclude all that is superfluous.

The client/owner participated in the process of building with the carpenter and made sure that the work was well done. Social constraints: people are not free to do what they may want to do. Neighbors depend on one another both in the communal building process and in daily life. The home offers space for each phase of life as different generations live together. Being part of the community means abiding by its rules. The rituals, holidays, the ascent of the cows to the pastures, political debate, the celebration of birth and commemoration of death bind the community together, but still ensure space for intelligent, individual action and, in rare moments of free time, even for decoration.

Life was hard and it would be an injustice to romanticize it.

Wandering through Ballenberg, we experience a sense of loss. But what have we lost – a sense of community, respect for an environment that belongs to everybody, a feeling of shelter or being protected?

The remedy to this loss is not a return to the traditional city or village but rather the acceptance of new constraints. Climate change is fundamentally altering the task of all those involved in the process of planning and building; we need new constraints and great resourcefulness to tackle current threats to the environment. These new constraints must rein in triumphant originality, vanity and self-expression, and as a by-product of this necessary process, we may well regain a new sense of community. The Ballenberg experience is an exercise in seeing

and understanding the qualities of building under strict constraints and, as such, an encouragement to gracefully accept new ones.

Rolf Fehlbaum

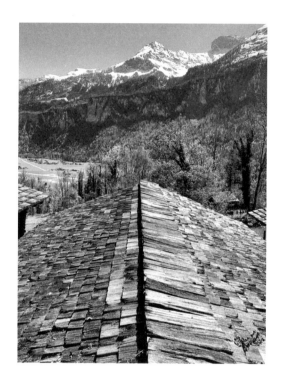

The rooftop echoes the mountain peak, providing a very Swiss view. TT

Initials (JM, DS, TT, FZ) refer to the authorship of notes and photographs; the number at the bottom refers to the number of the building at Ballenberg and in the index of buildings.

1341–1345

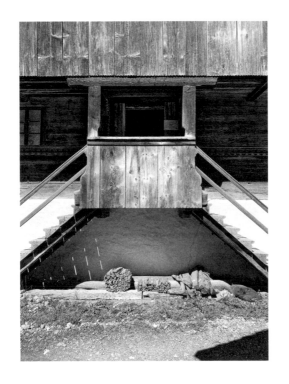

Everyday life decides which steps you take. тт

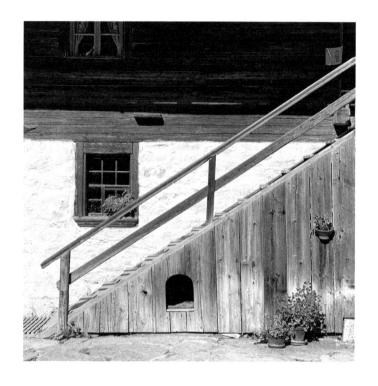

A linear flight of steps, a place for the dog and a couple of flowerpots work together to provide a warm welcome home. FZ

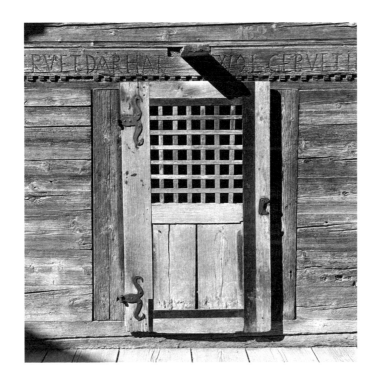

The contrast between the orthogonal composition of the wood planks and the free form of the metal hinges makes this door rather special. FZ

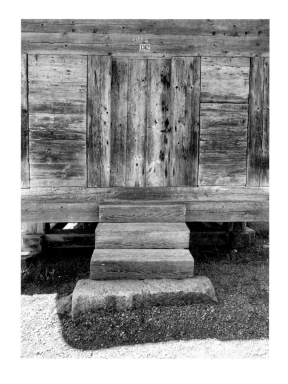

The minimalism of wood, plus one stone before the steps. ᴛᴛ

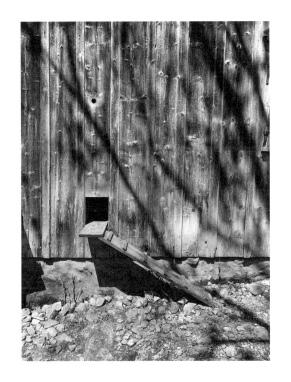

Entrance for friends. Steps and distances are kindly designed. ττ

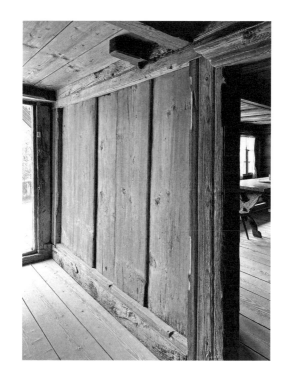

In a world of wood paneling – as often fake as real – it is interesting to see interior walls constructed entirely of massive planks. DS

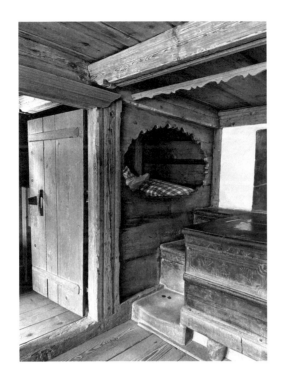

I imagine you would need to be fairly high up in the family hierarchy to secure a place in this bed. It would be a majestic luxury to slowly absorb the heat of this stone oven through a long winter night in the Alps. DS

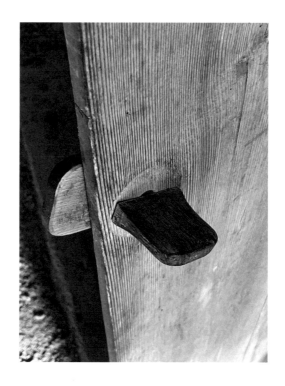

Is there a more pleasing door opening device in this world? Most likely developed by a local carpenter, it exhibits the functional and aesthetic qualities of a masterpiece of practical thinking and design at its purest. The handle's shape resembles a duck's bill and is thinnest halfway along it to improve grip, widening where the handle meets the door to provide better stability. No instruction manual needed! JM

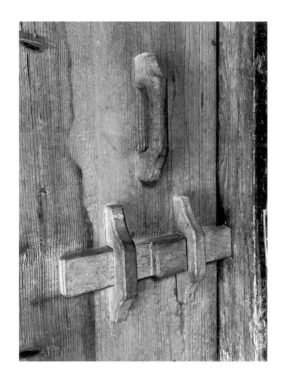

A substantial wooden slide bolt with a stopper, but strangely missing a grip to open it with. JM

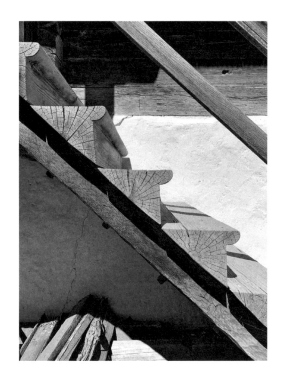

A good carpenter knows that the wood speaks to him and shares its joy of detail. ᴛᴛ

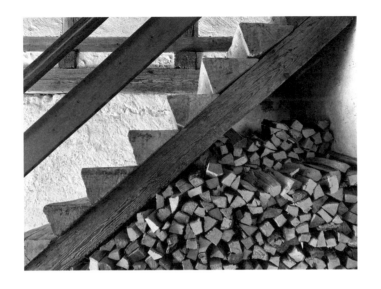

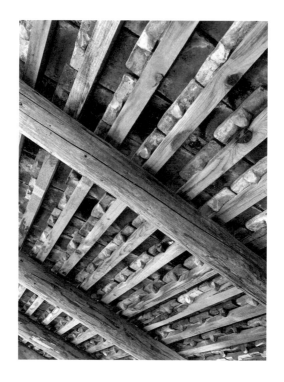

The discovery of a small moulded "snag" on the back of each tile
that holds the roof on. ττ

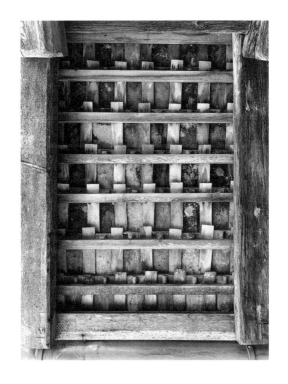

The first lesson of architecture is the importance of rhythm. ττ

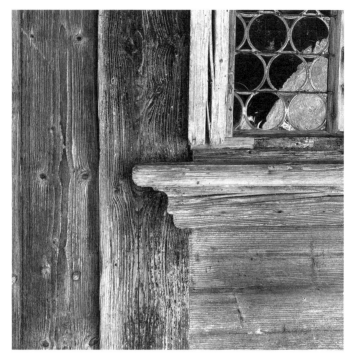

FZ

*One has to free oneself from "ties," not simply throw away the past and all its history; the past must be considered as a historical present. The past, seen as historical present, is still alive; it is a present that helps us avoid various pitfalls. In the face of this historical present, our task is to forge another "true" present, which does not call for profound specialist knowledge, but an ability to understand the past historically, to be able to distinguish what will serve new circumstances that now present themselves, and this cannot be learned from books alone.*

Lina Bo Bardi

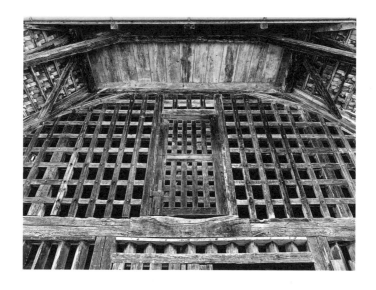

A steady wind is brought into the upper room to keep stocks dry,
while on the ground floor diagonally arranged slats filter light and ventilate
the workroom. Architecture in dialogue with nature. ⊤⊤

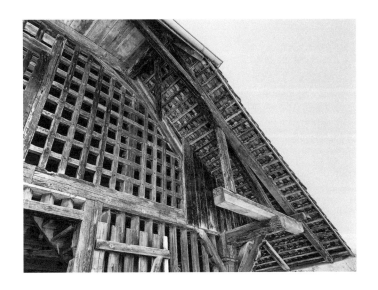

The exquisite balance in the upper right roof eaves. Poised between gravity and support or push and pull – that is structure. π

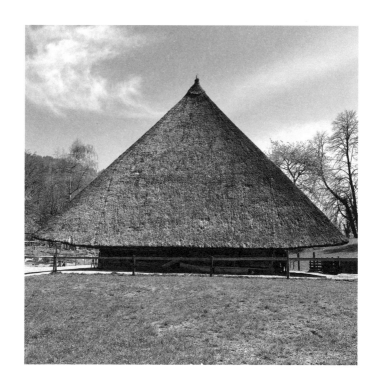

A good hat is the best protection. DS

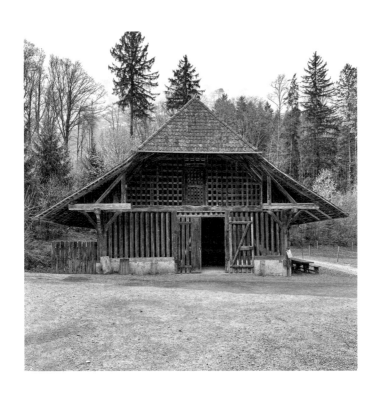

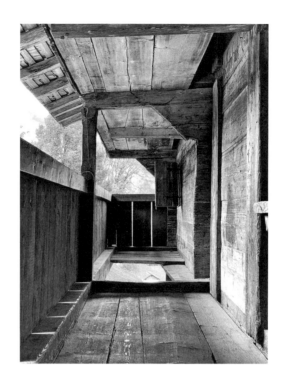

A covered corridor leading to a staircase. The steps could have aligned with the door, but that would have deprived the house of this space between indoors and outdoors. I'm struck by how Japanese the character and atmosphere of this is with its slightly open-planked balustrade and the minimal way the planks and boards and structural members combine to softly shape and express the being of this place between. JM

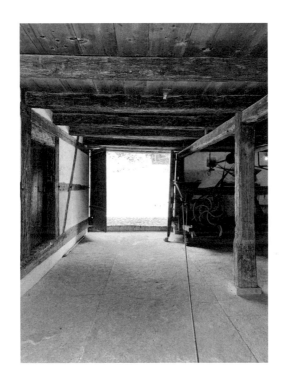

Entrance, workroom or shed? What does one call this functional space, does it need a name? тт

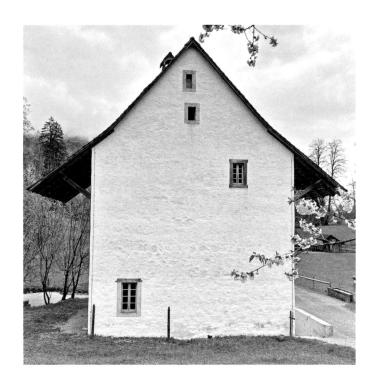

When form finds itself from within, things just look like they end up looking. DS

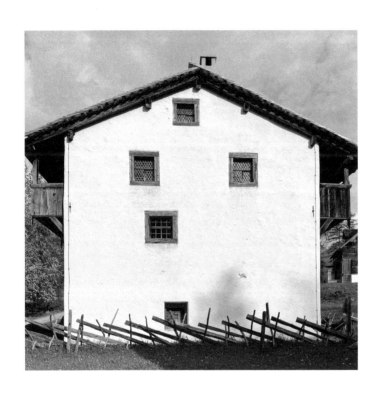

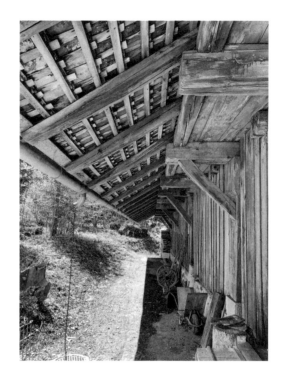

The main rule of construction is the repetition of elements. π

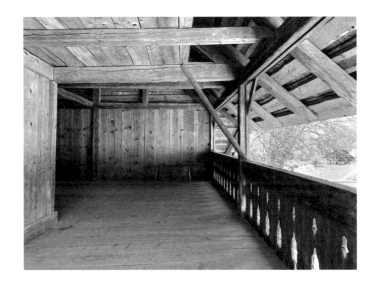

This veranda seems like a happy place, busy at times and sometimes relaxing, depending on its use. ᴛᴛ

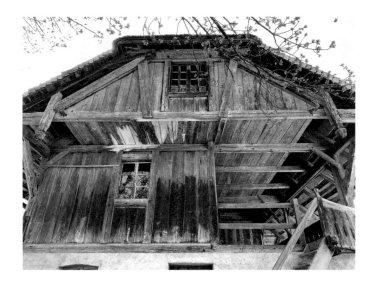

The overhanging room offers a view and is structurally well-designed. ττ

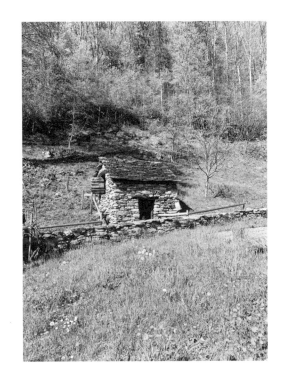

The secret of durability is modesty. TT

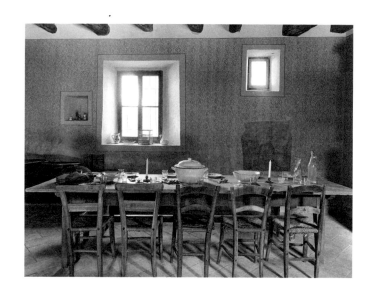

After some time, furniture and architecture become one. TT

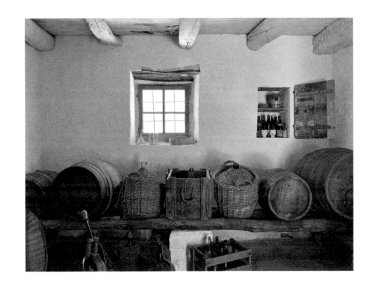

Important items are stored in the storeroom, and more important items need a place to hide. ᴛᴛ

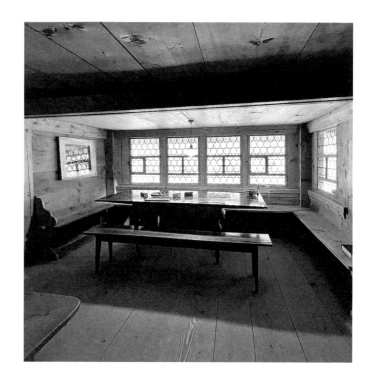

The architect Aldo van Eyck wrote, "Whatever space and time mean, place and occasion mean more …" The dining nook might be the archetype of place and occasion, where walls, windows, floors, ceilings, tables and chairs join the clatter of forks, spoons, plates and people in one indivisible thing. DS

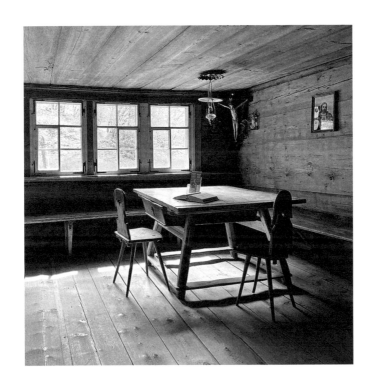

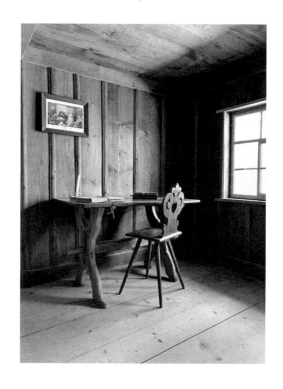

This corner offers a place for the philosophy of life that has disappeared in modern spaces. TT

*As an architect, I believe in and so cannot subscribe to copying the architecture of an era which is long past. As an architect, I believe in building to suit our living needs in a living way, utilizing the most suitable modern and progressive means at our disposal, and only adopting those sound fundamental principles of building of the past, which are as authentic today as before. It is from this that a beautiful and satisfying modern architecture can result.*

Minnette de Silva

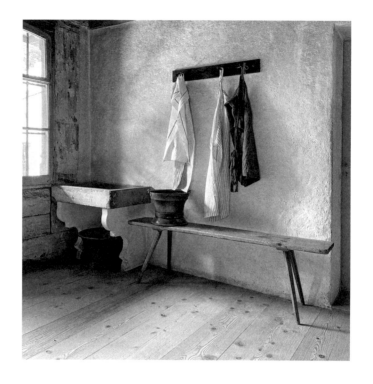

The position of the stone basin not only allows for easy drainage of the water towards the exterior, where it can be reused, but also frees the rest of the wall to the side. Towels and aprons can be hung at a convenient height above a simple bench. Why does this composition of objects and fixtures feel so right? It is a matter of finding the right spatial intervals on a gently lit surface. FZ

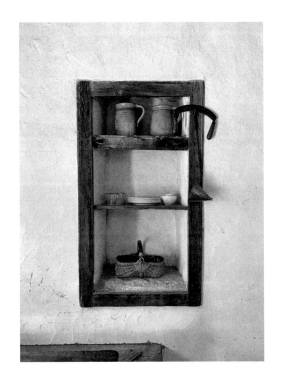

A frame makes even the humbler everyday objects look special. FZ

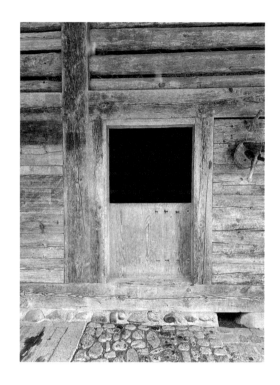

The solidity and flatness of the doorway and neighboring post combine in a most unlikely, satisfying way. The half-door completes the composition, leaving a finely proportioned opening for the farmer to inspect his stock. JM

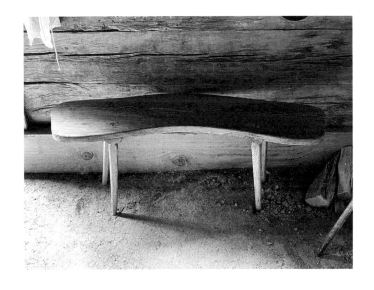

An unusually beautiful plank bench made to avoid the awkwardness of two people sitting side by side, the curve encouraging a more angled seating position. The legs are almost too close together to comply with modern-day safety regulations. JM

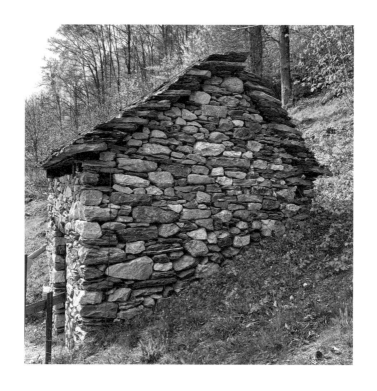

The shortest path from nature to architecture – and back again. DS

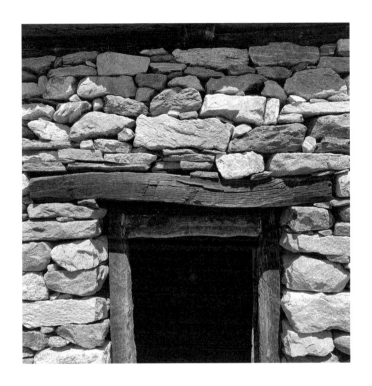

The bent and twisted architrave demonstrates the effort required for dealing with the weight of the stone wall above the opening. FZ

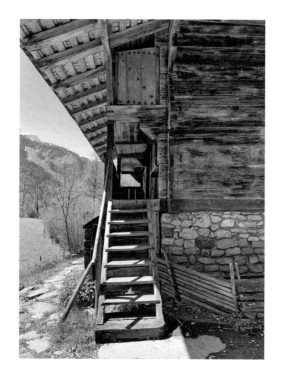

The day begins by going downstairs, the day ends going upstairs. TT

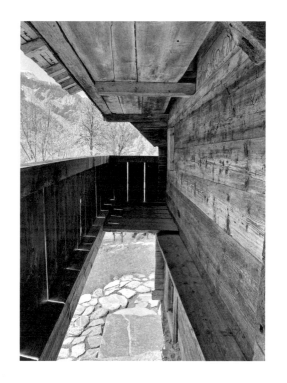

*I looked at all the villages, all the houses, to at least try not to do anything less well and equally not to do the same thing, but to understand their essence. And this can be achieved without shame, despite being avant-garde and with traditional materials, on one condition: that they are treated properly technically, in their relationship with humanity.*

Charlotte Perriand

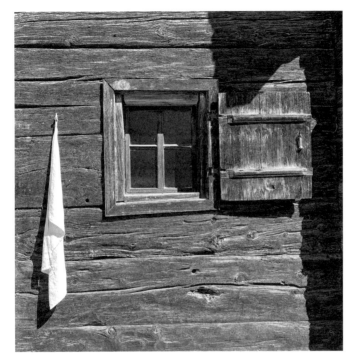

FZ

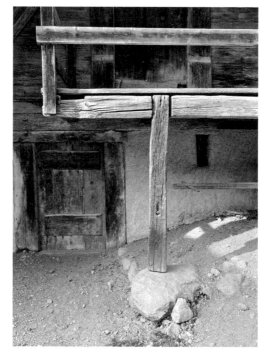

DS

*There is much to learn from architecture before it became an expert's art. The untutored builders in space and time […] demonstrate an admirable talent for fitting their buildings into the natural surroundings. Instead of trying to "conquer" nature, as we do, they welcome the vagaries of climate and the challenge of topography.*

Bernard Rudofsky

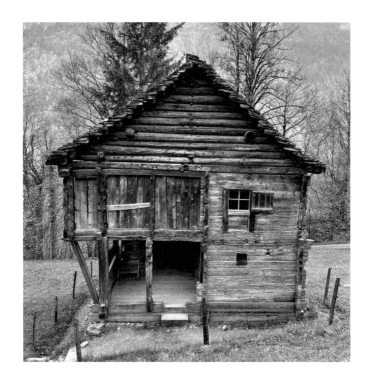

One might imagine the simple gabled house of a child's drawing would leave little room for invention, but there is remarkable diversity – from every angle of roof pitch, symmetry to asymmetry, and spaces set back and projecting out, innumerable types and sizes of openings, and a wide range of materials used both between or within each structure. The buildings appear to evolve through a kind of architectural natural selection within the demands of function, available resources and the climate and geology of their micro-environment. DS

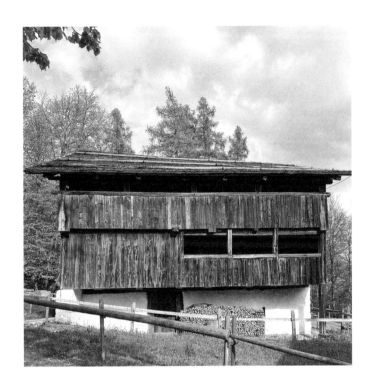

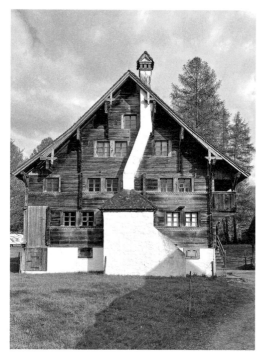

DS

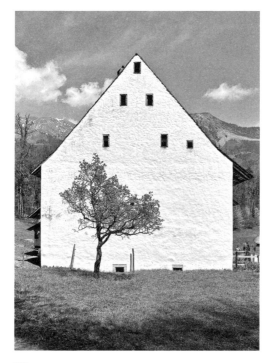

DS

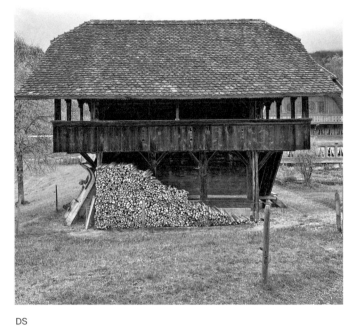

DS

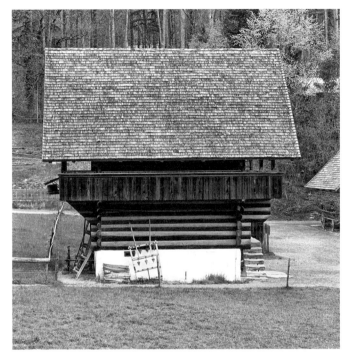

DS

332                                                                63

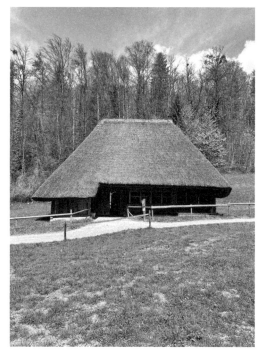

DS

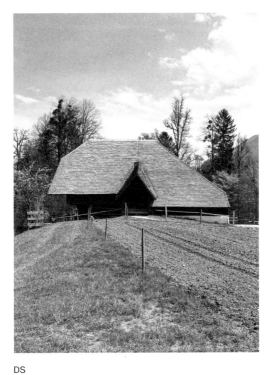

DS

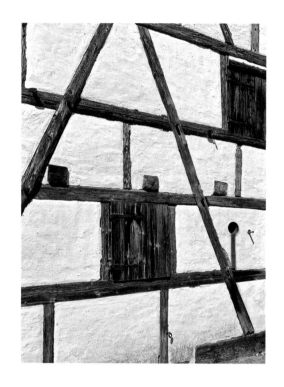

The complexity of how the wooden structure of the wall is formed as a resistant structure. ㅠ

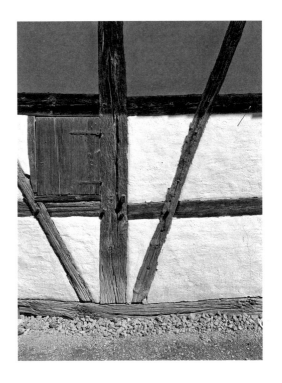

Just as people age, the roughness of time adds beauty. ㅠ

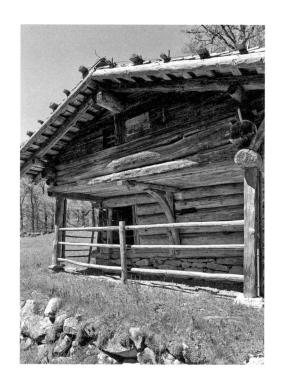

The overhanging room creates the milking hut's form and gives shelter to the cows. TT

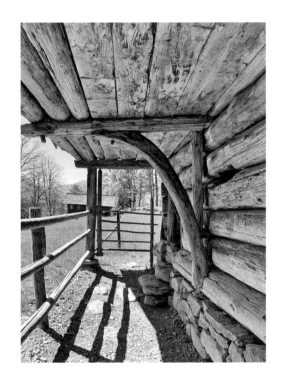

Use the strength of nature's forms. ᴛᴛ

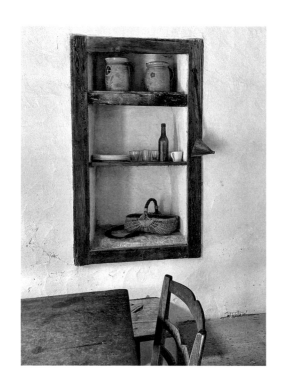

A recessed shelf makes perfect sense if it's in the right place; it can only reasonably be achieved while a house is being built. The wooden frame enhances its status and suggests there might once have been a door. JM

*If we study the various forces that appeal
to us all in these traditional dwellings,
we will no longer do formalism, constructivism;
we will not affirm the curved or the straight
line, the stone or the cement, the blue
or the red, the wood or the metal, but
we will use each in its useful place, technically
and physiologically. The study returns to
a human level.*

Charlotte Perriand

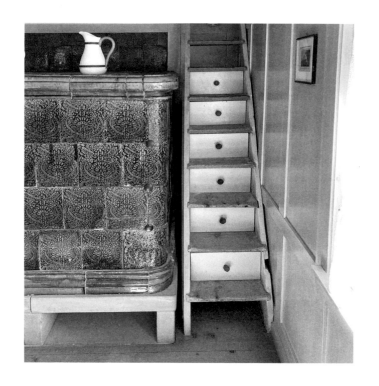

The staircase might be narrow, but drawers set in between the steps make good use of the space below. The garments and household linen were certainly kept warm and dry in there, no matter how damp and cold the winters were. FZ

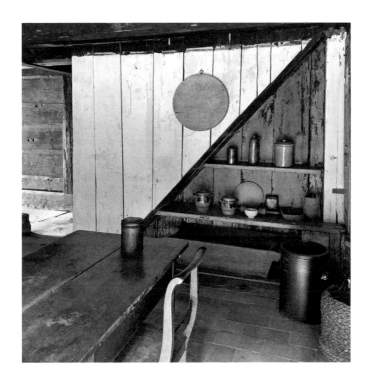

An otherwise dark and gloomy corner is brought to life by shelves and the objects placed on them. JM

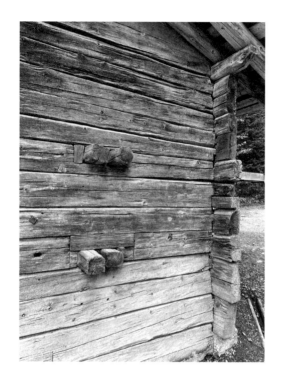

Things tend to pop out, so let them. DS

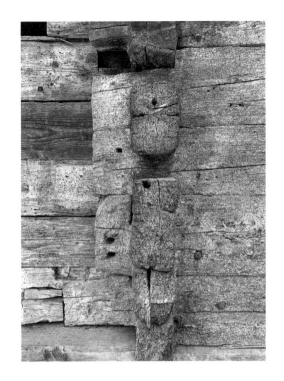

Sometimes the texture of the wood looks like elephant hide.
This must be the kindness of time. ттт

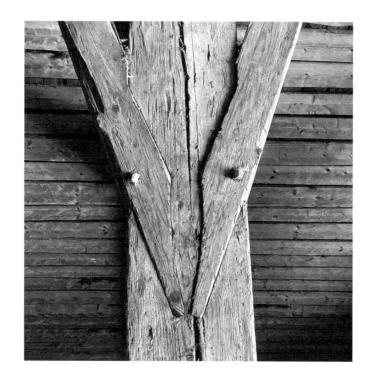

Structural and aesthetic dexterity converge in these two wooden pillars, where the elegant design of the joints actually stands for efficiency, eliminating the need for nails and screws. FZ

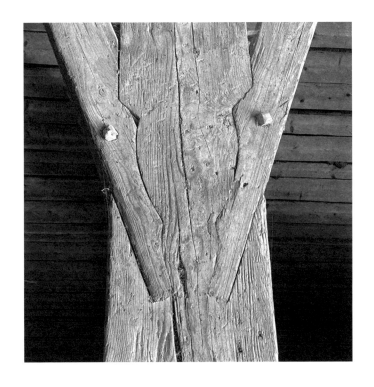

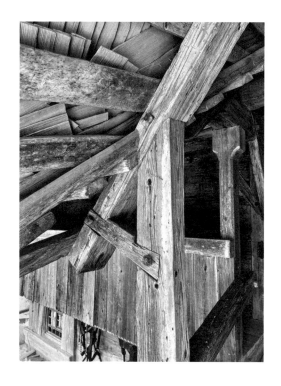

With great confidence in the generous and accommodating nature of wood, a fearless convergence from at least seven different directions pulls it all together in the end. I am reminded of John Coltrane: "I start in the middle of a sentence and move in both directions at once." DS

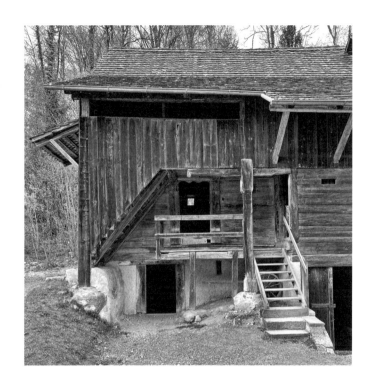

This corner is impressive for the great number of things moving up, down, forward, back and sideways. Aside from admirably resolving functional requirements, it is a rich and pleasing composition. DS

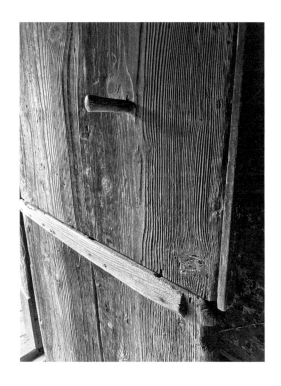

An unusual but valid means of pulling a door closed, possibly explained by being easier to make than other handles, quickly turned on a lathe by a local craftsman and inexpensive. JM

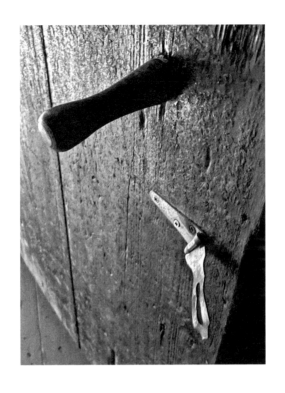

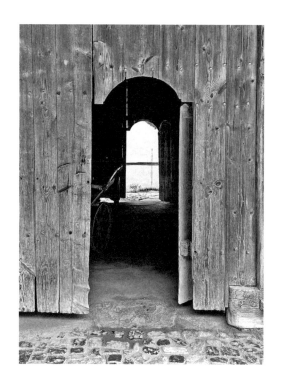

The evolution of decoration? DS

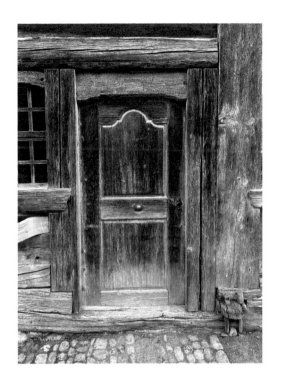

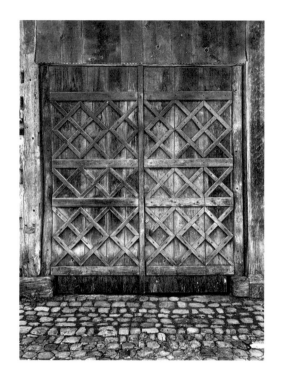

It takes a generous heart and mind to create richness from simple materials. ᴛᴛ

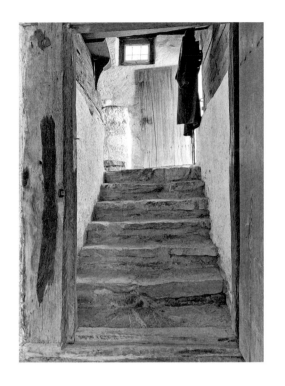

Inside and yet outside. A life in the mountains and life with the mountains. π

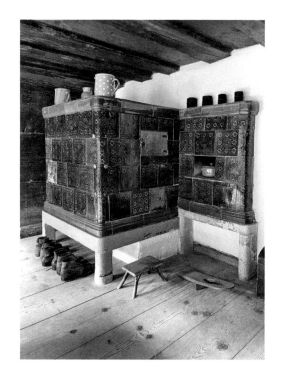

A simple plastered base supports the volume of this green-tiled stove; the extended wing receives the benefit of the fire to boost the surface area warmth and keep some heat in the pot. JM

*We cannot revive old traditions any more than we can invent new ones – but there is much to be learned about the way traditions grow and the way they function. The tradition, or lore of an art, helps the artisan bridge those gaps where he lacks sufficient current information upon which to base a decision. Innovation which usually takes place outside the restraints and assets of tradition often suffers from the lack of many obscure bits of seemingly unrelated information, small but vital bits of information which accumulate slowly in the development of tradition.*

Charles Eames

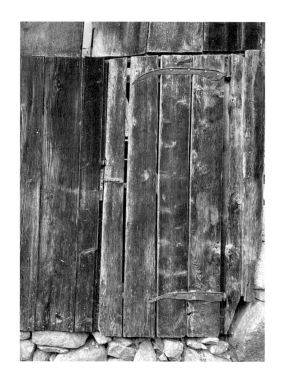

Adaptive re-use. DS

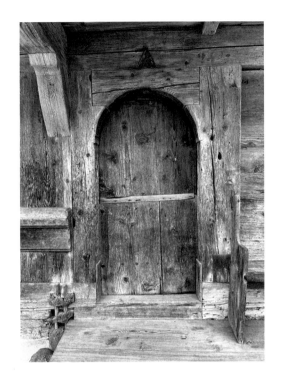

Effective for keeping smaller, two-legged beings at bay while letting in some fresh air, well-suited for chatting with a neighbor, practical for collecting a package. The stable door of the country might do just as well in the city. DS

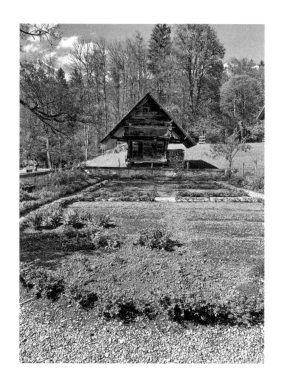

To live is to eat, and village life is a balance of growing food and living together. ᴛᴛ

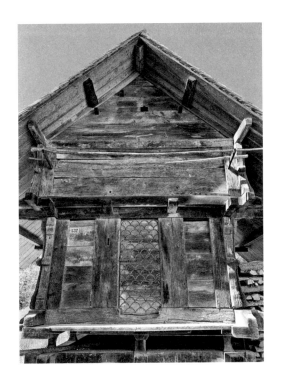

Special door, and don't miss the vent at the top of the granary –
or is it an opening for spirits? ττ

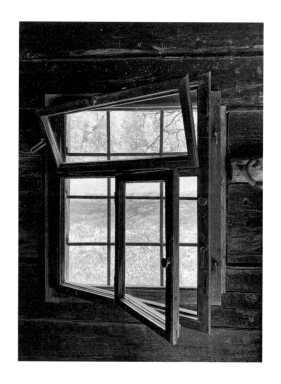

Three windows in one opening – an efficient invention to welcome seasonal breezes. TT

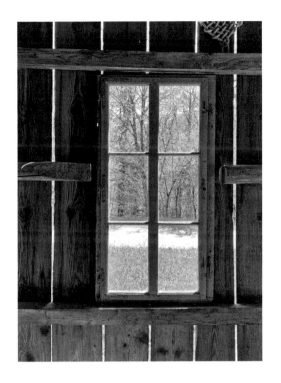

The external planks are thin and wide, while the internal structures are thick and stand out from the wall. тт

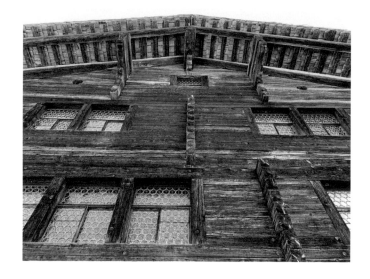

The longevity of wood is exceptional. It is majestic and generous
in appearance, modest and grand in nature, with the eloquence and depth
of an old man who speaks little. ᴛᴛ

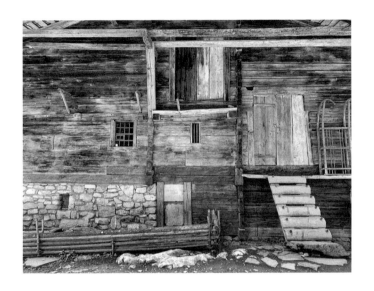

Life is a complex, ambiguous process of activity over time, which is beyond our full understanding. тт

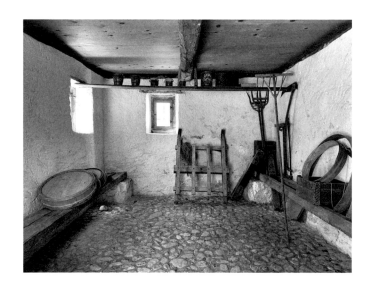

Tools need a place to rest when they are not at work. ττ

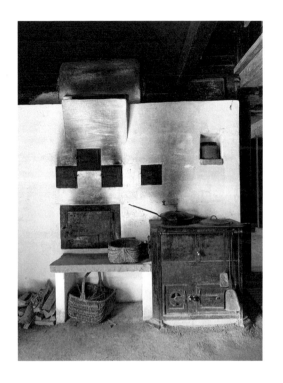

Flow forms function. тт

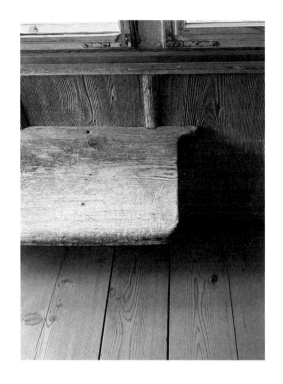

Pleasing variations. DS

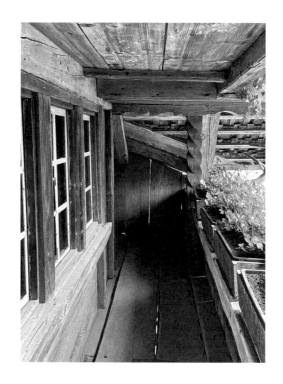

Look at that! On a balcony outside the bedroom, amidst the rational structure of this farmhouse, a hand-carved spiral column: modestly unpainted, it manages to sit within the surrounding structures in a charmingly unpretentious way, just there to please the eye and lift the spirits. JM

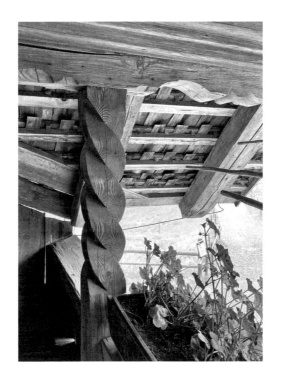

*Vernacular architecture does not go through fashion cycles. It is nearly immutable, indeed, unimprovable, since it serves its purpose to perfection. As a rule, the origin of indigenous building forms and construction methods is lost in the distant past.*

Bernard Rudofsky

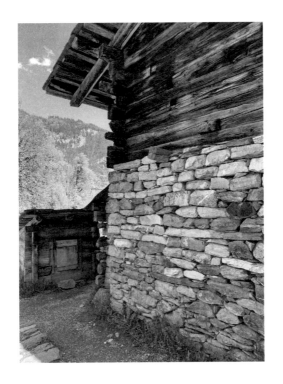

The stone lives longer, more than enough to support the life of wood. ⊤⊤

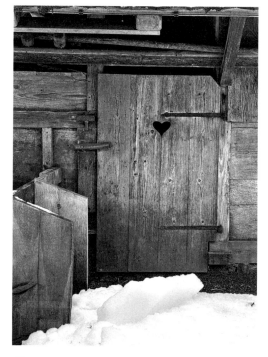

FZ

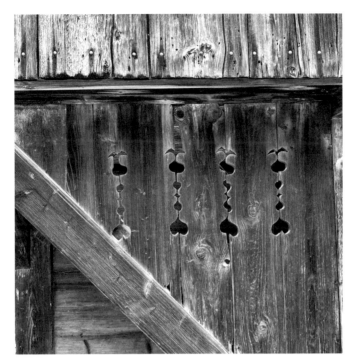

DS

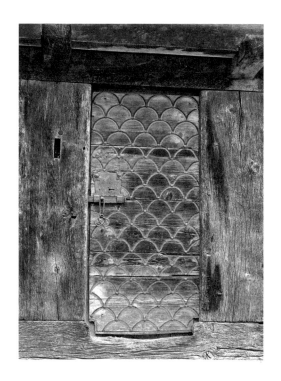

I admire the oxblood and offset black fish scale pattern on this storehouse door. The building is particularly beautiful, and the owner must have wished to finish the door with something a little richer than the bare horizontal planks. Was this a local builder's regular pattern or was it something more common in the area? The richness comes from the contrast between the black and the oxblood lines. A clever trick, like black eyeliner sharpening the definition of eyelids. JM

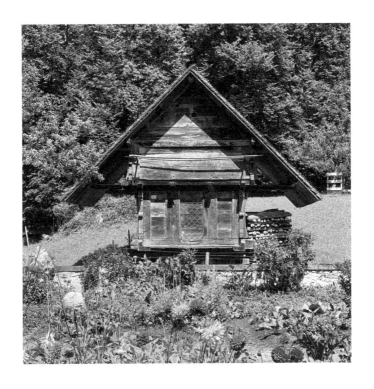

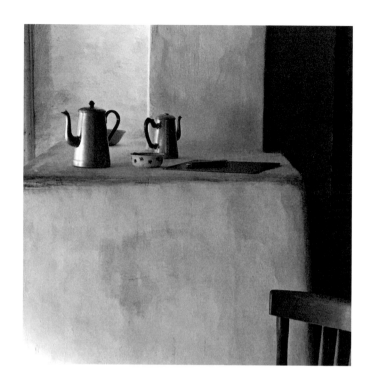

Signs of life. Useful objects in architectural settings suggest and define the use of space. An armchair and a bookcase would send a different message. JM

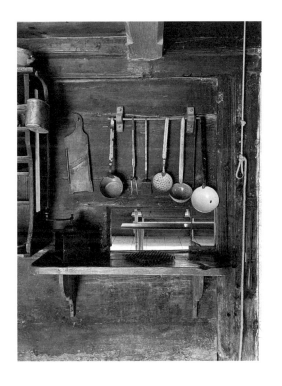

*Handmade products appeal to us because they express the mood of the craftsman. Each irregularity, oddity, difference is the result of a decision made at the moment of manufacture; the change of design when the craftsman gets bored with repeating the same motif, or a change of color when he runs short of one color or thread, witness to the constant living interaction of the man with his material. The person who uses the object thus made will understand the personality of the craftsman through these hesitations and humors, and the object will be a more valuable part of his surroundings for this reason.*

Hassan Fathy

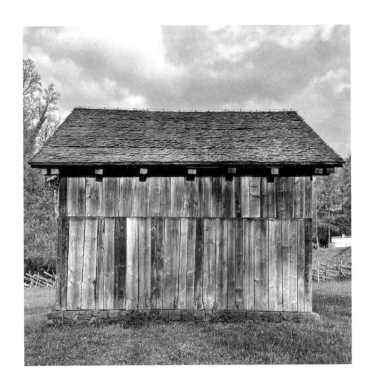

Planks in different widths, almost never cut straight, almost never aligning, with the rafters almost equally spaced – a fine composition, perfectly measured by an almost perfect horizontal joint. DS

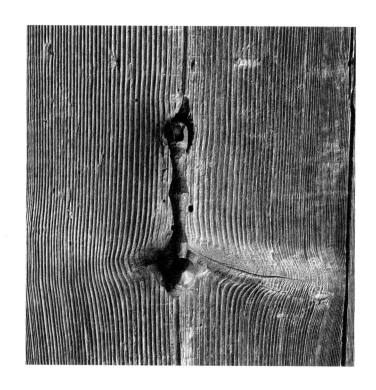

On getting old: the grain of the wood works well with the oxidation of the metal. FZ

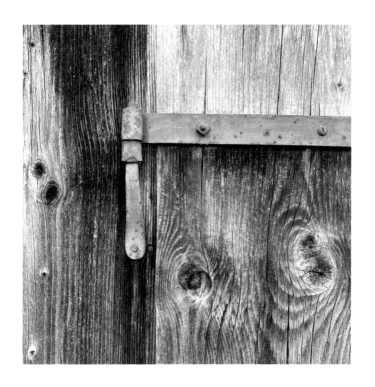

The art of forming connections. FZ

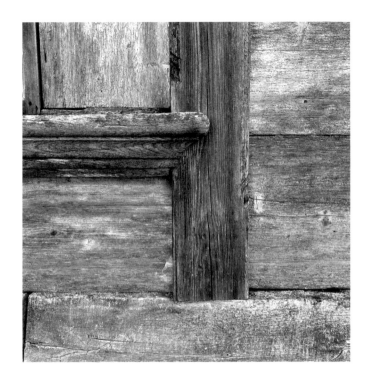

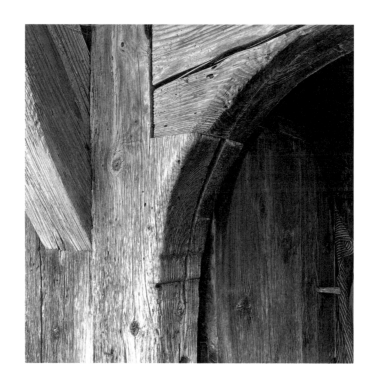

Details made softly, like signs of affection. DS

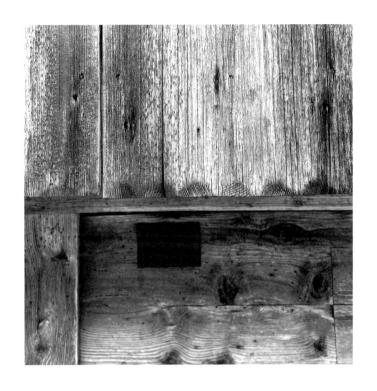

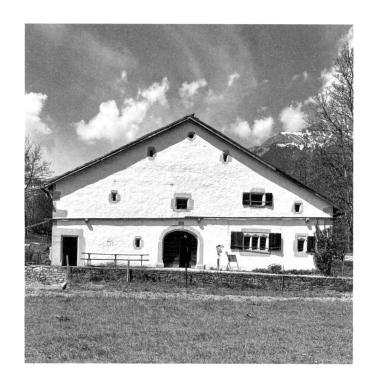

Living and working become one under one roof. DS

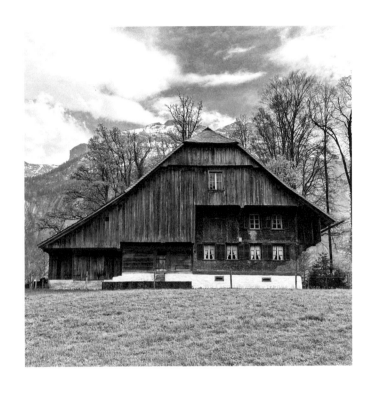

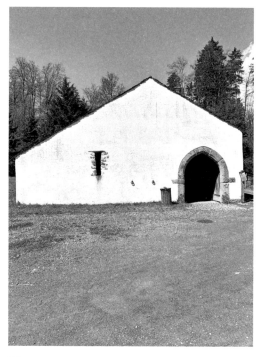

TT

*It is certainly noticeable that all great buildings do have various small irregularities in them, even though they often conform to approximate overall symmetries and configurations. By contrast, buildings which are perfectly regular seem dead. This arises because real things have to adapt to irregularities in the exterior environment correctly. They become partially irregular in response.*

Christopher Alexander

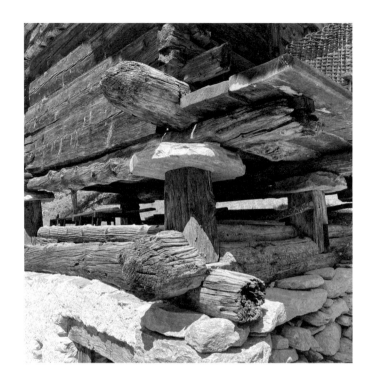

Gravity, and two different ways to manage and express it. The round stone disc collects the weight of the corner and conveys it to the pillar while preventing mice entering from below. FZ

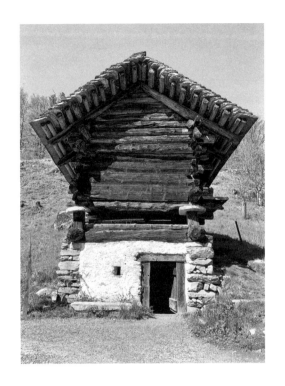

A stone room supports a wooden granary; each material shares a detail of the other and they interact very well together. ττ

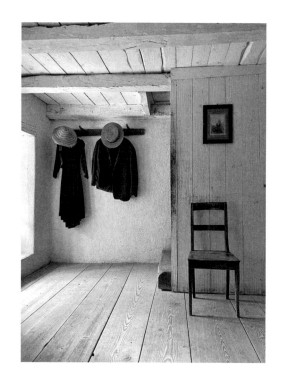

Something rather perfect about the arrangement and materiality
of this first-floor bedroom. The solidity of the white outer wall contrasting
with the similarly painted wooden stairway partition with its paint worn
away from handhold wear. The lowest wooden step announcing the others,
the width and grain of the untreated floor – boards washed smooth,
the quality of the light. All bear witness to an unadorned, simple life. JM

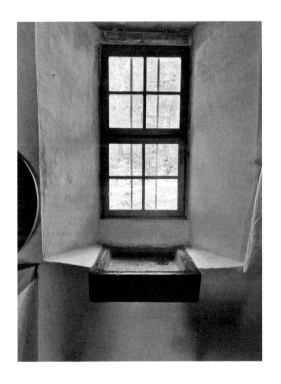

In my good old days, at least, you could find a window above every kitchen sink, but it would be a rare thing to see one in the kitchen of any contemporary flat or house (not to mention a window in the bathroom). Having direct access to natural light, fresh air and a view in places of the most everyday of life events is an idea perhaps so obvious that it is easily forgotten. DS

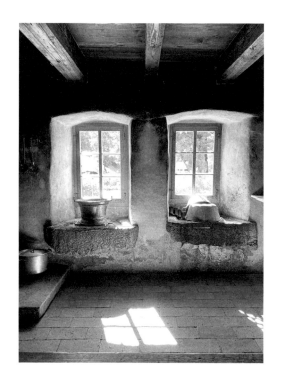

Windows in pairs, once frequent in architecture, are now often substituted by efficient floor to ceiling openings providing plenty of light and sweeping views outdoors. It is a matter of personal preference to choose between such permanent exposure or the sense of protection and pleasant symmetric arrangement allowed by thick walls sparsely pierced according to necessity.
FZ

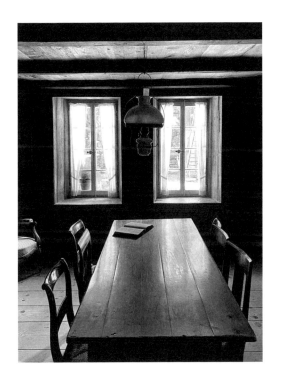

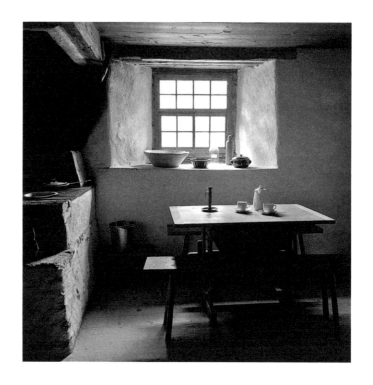

A window deeply set in a thick stone wall functions as a well-lit shelf.
A window inserted flush in a wood frame wall becomes part of the geometry
and visual composition. In both cases the result is an inviting and
intimate setting. FZ

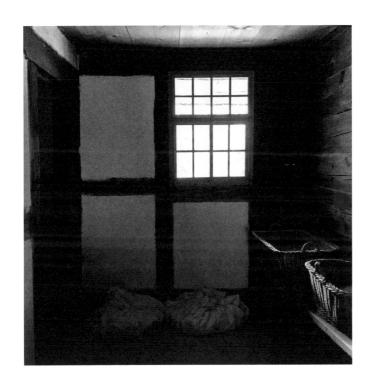

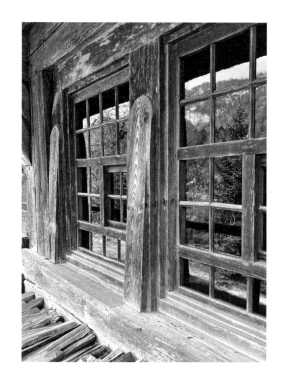

This window detail is peculiar with its cascading profile that invites your eye to follow its edges. Something more like seventeenth-century Roman Baroque than the Swiss countryside. Given Francesco Borromini's Swiss ancestry, there might be something in the water. DS

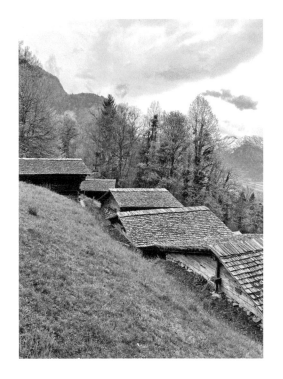

Finding their place as naturally as the mountains they have settled on. DS

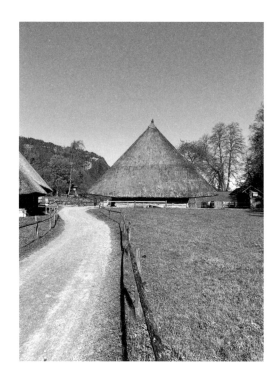

The large roof would have been a symbolic form in an otherwise untouched landscape. ㅠ

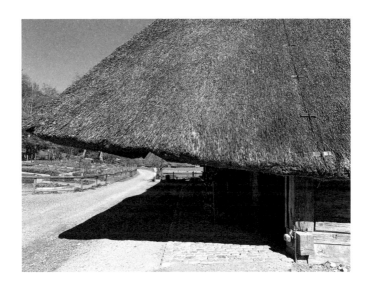

The light thatched roof creates large, low eaves, providing a blurred border between the house and the street. ττ

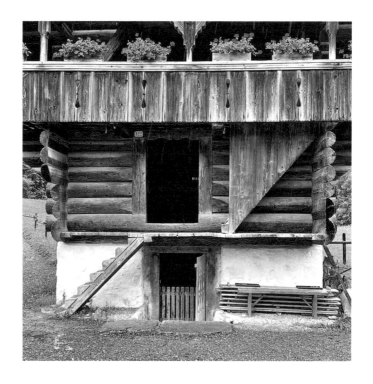

How much more real is a house made rather than built. Instead of truckloads of building materials on pallets, cement mixers pumping concrete into precisely arranged foundation trenches, builders with high-speed power tools and convenient chemical products, wall cavity insulation products and spray paint guns, carpenters arrived with their tools and made the house to your needs with the knowledge of centuries of trial and error to maximize

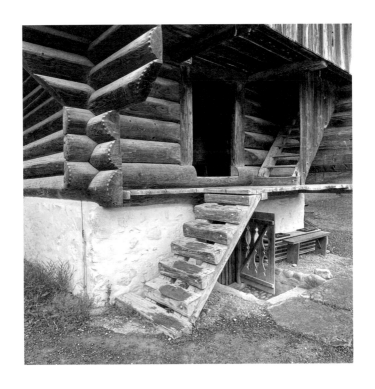

function, performance and durability. The building trade has evolved largely to maximize construction company profits at the expense of traditional methods and knowledge. Roofs leak, damp rises, and cracks appear, while an endless procession of technicians visit to correct the faults. Life was hard in these handmade houses, but it was real. How much better it would be if we developed that knowledge to meet our modern needs. JM

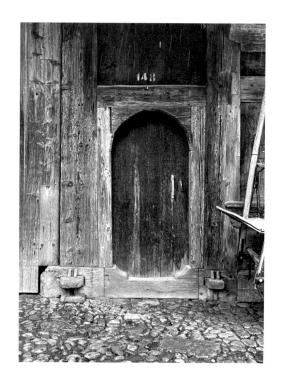

Seeing this doorway one understands the term "door frame" much better.
For the cost of stepping over the elegantly carved floor beam, it would protect
the house generously against blown-in leaves and under-door drafts. JM

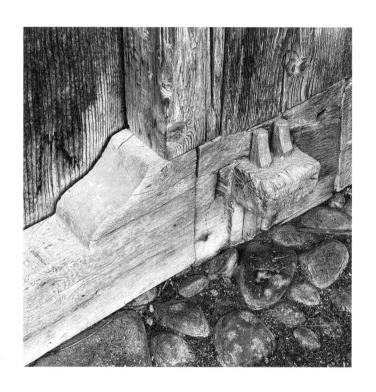

*Things which have real life always have a certain ease, a morphological ROUGHNESS. This is not an accidental property. It is not a residue of technically inferior culture, or the result of hand-craft or inaccuracy. It is an essential structural feature without which a thing cannot be whole.*

Christopher Alexander

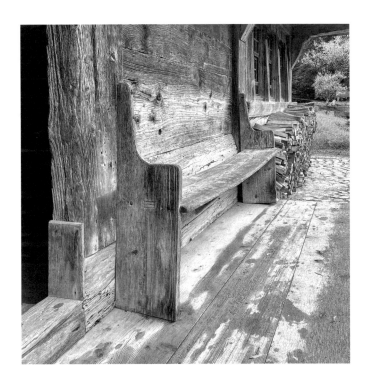

There is something uplifting about benches, tables and other bits of furniture which are part of the architecture of a house. They make the architecture more functional and improve the atmosphere. In this case the bench, presumably accompanied by a table in warmer weather, is notable for the addition of a comfort-boosting, sloping plank where the wall meets the seat, combining satisfying extra comfort and improved posture for the lucky householders. JM

351                                                                                      139

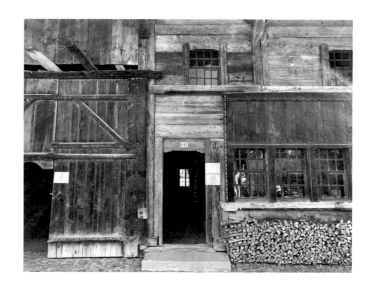

Addition, subtraction, division, multiplication – living architecture can evolve no matter what. ττ

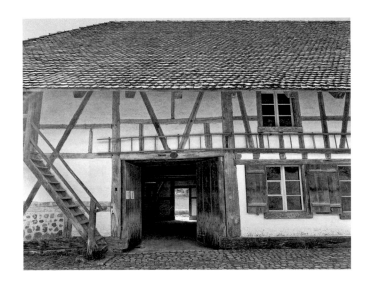

The house welcomes the land to connect front and back.
But for some reason, a long ladder is placed above the opening. ᴛᴛ

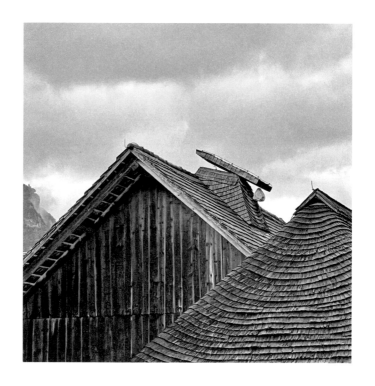

Who hasn't questioned the efficiency of European fireplaces and chimneys?
With a fire burning they draw in air from wherever they can find it; inevitably
it's the cold air from outside the house. Without a fire they make it easy
for any warmth in the house to leave, drawn up by the colder air above.
In a storm, the system reverses and cold air gets forced down the chimney.
But here's an improvement we could all adopt, consisting of a counterweighted
hatch held down by a cord which runs down the side of the chimney to the

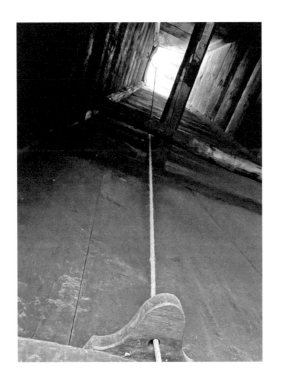

fireside, where it can be adjusted as needed, fully closed when not in use, fully open when lighting the fire, and slightly open when it's up and running. JM

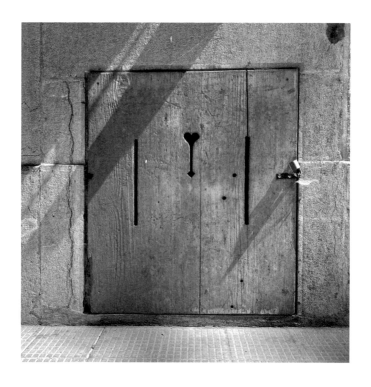

This simple shutter reminds us of the necessity of breathing. Before we started to rely on energy-consuming mechanical ventilation and tightly closed, air-conditioned living boxes, we used to appreciate a bit of breeze flowing in from the outside. All the better if it comes through a small heart-shaped cutout. FZ

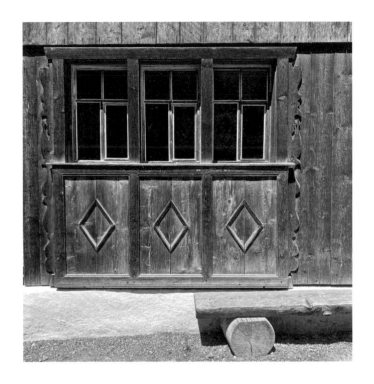

The frame and lozenge appliqués enhancing the window signal that behind it lies the main space of the house. FZ

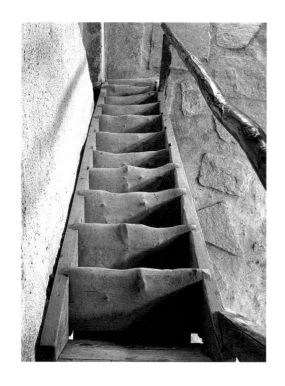

No need to fix what isn't broken. DS

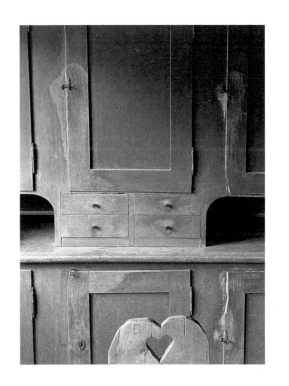

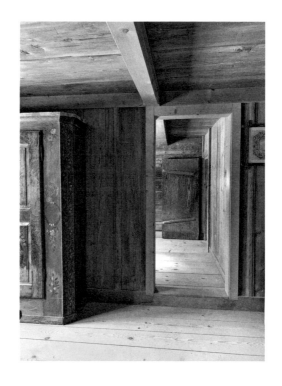

A house that can be renewed from generation to generation. Its memory coexists in the old and the young pieces. ᴛᴛ

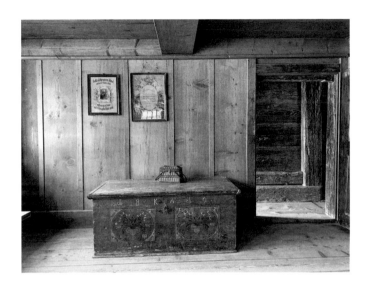

The chest in the house is a small architecture which contains memories of past lives and the future of others. ττ

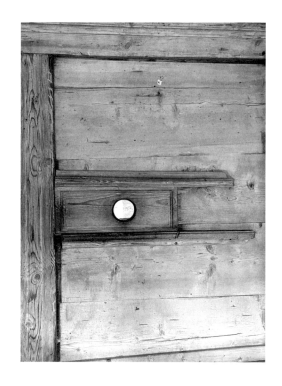

Not sure if these are a practical way to serve dinner or an effective way to ensure the best behavior of visiting suitors. I would guess both! DS

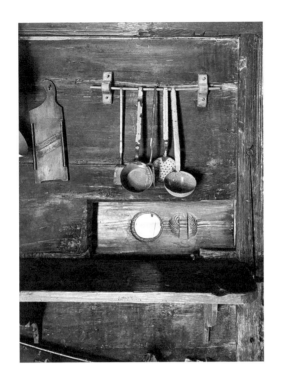

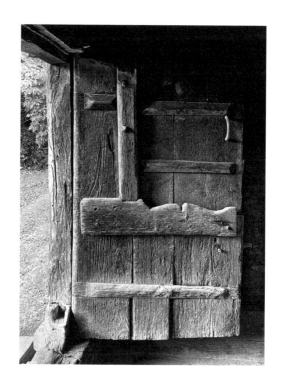

How to explain this assortment of battens reinforcing the door? It's unlikely this was the original design; some of the more random elements were probably added to close a gap or reconnect the verticals. JM

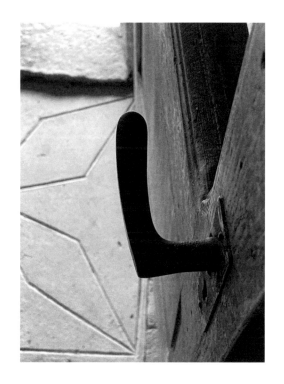

I know this handle from travels in Italy, but seeing it in this rustic setting caused me to rethink its character. Imagining it hand-carved from a wooden branch, it lost all feeling of an industrial product. JM

*An instinctive response reacts to quality in form. It was once suggested that this innate sense of quality in architecture could best be exercised by evaluating four features of a house, and finding in them a certain measure for the success or failure of the builder's intentions. These four features were specified as: the roof, the corner, the base and the access.*

Sibyl Moholy-Nagy

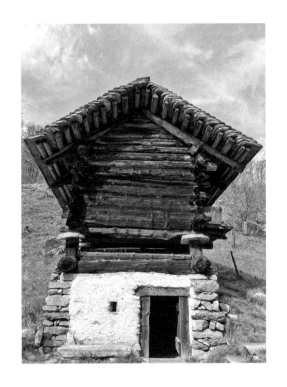

A building like a diagram of how it was made. DS

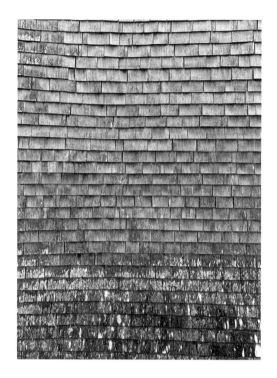

This house is rationalist; it prefers hard, square and organized. TT

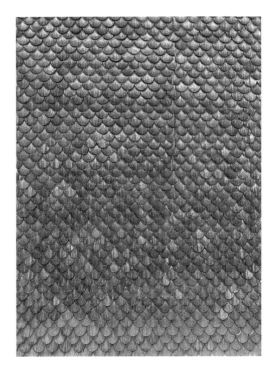

This house is pastoralist; it prefers soft, round and generous. TT

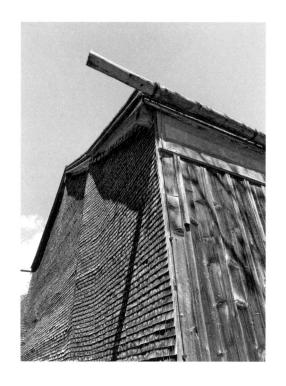

Good design born of good thoughts. TT

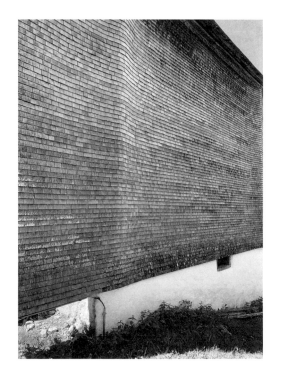

Curious curve from inside to outside. TT

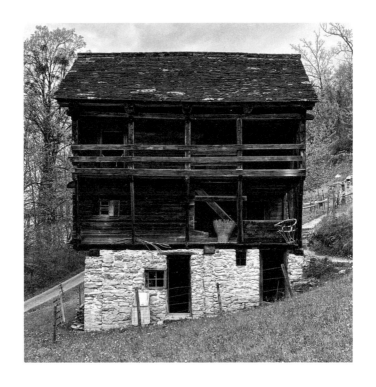

Many of the buildings bring the stairs and hallways to the perimeter, creating protected and pleasant outdoor spaces for work or rest, while allowing the interior rooms more space and freedom for direct and natural relationships, including such luxuries as having a conversation with someone cooking breakfast while you remain warmly tucked in bed. DS

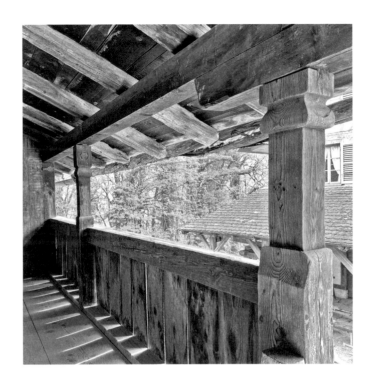

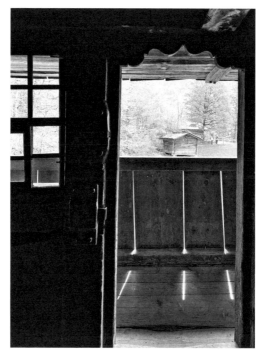

DS

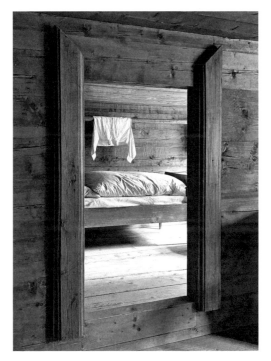

DS

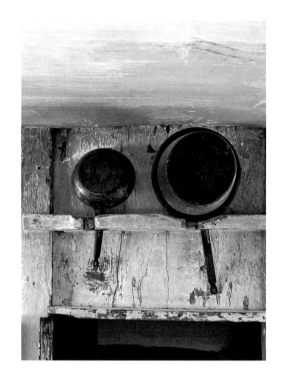

Decoration creates itself. DS

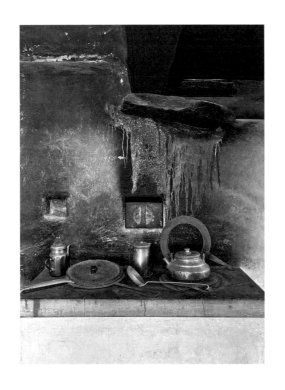

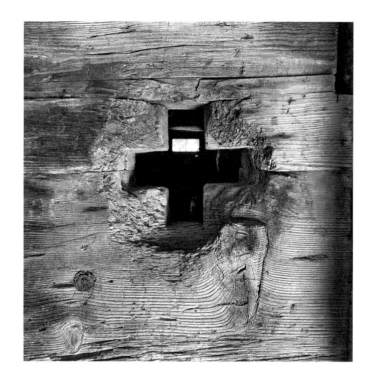

Of all the ways to make a hole in a thick wood plank, this doesn't look like the most efficient. But Swiss it certainly is. FZ

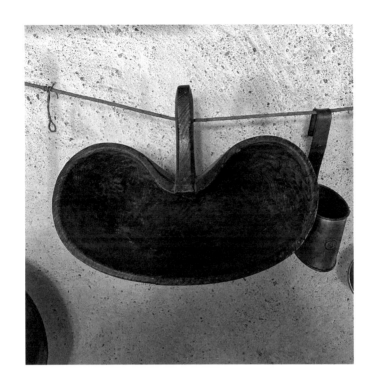

The beauty of this large carved ladle ... was it possibly used to scoop cream off the milk or something to do with cheese? FZ

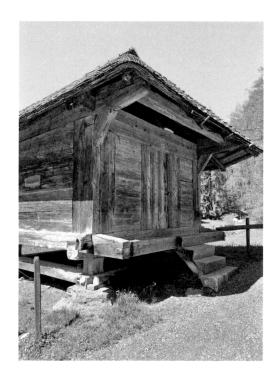

Simplicity transcends time and culture, and craft conveys the traces and spirit of handwork. TT

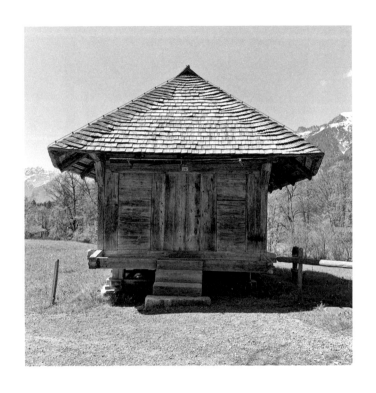

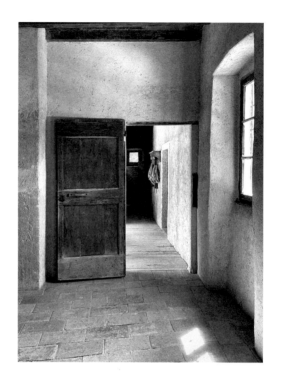

This brick tile floor from Ticino is notable for the quality and precision of the tiles and the pleasingly irregular arrangement of the rows, the T-junctions being sometimes mid-tile and sometimes nowhere near. The sharpness of the tiles' edges and the regularity of widths allow the floor to be laid without the usual boring cement grouting, resulting in a kitchen floor of enviable beauty. JM

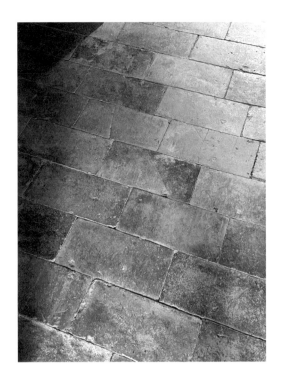

*The one man missing in this building venture was the architect. The owner dealt directly with the men who did the work, and he could see what he was getting. For their part, the craftsmen were free to vary their designs within the limits of tradition and subject to the owner's approval. If an architect had come between owner and craftsmen, he would have produced plans that neither could understand, and, unable to escape from his drawing boards, would have remained quite ignorant that the variations of detail possible in a design make all the difference between a good house and a bad one.*

Hassan Fathy

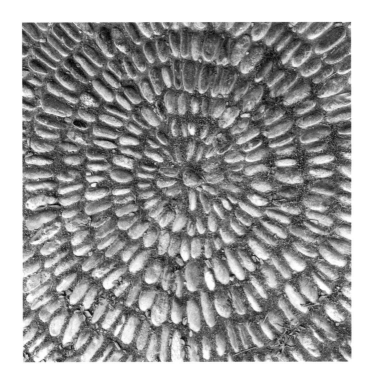

A pleasant way of paving and draining as well. FZ

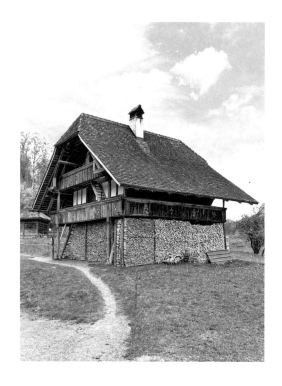

This dense layer of chopped wood would provide a great deal of insulation at the beginning of the cold winter, and as the stockpile slowly diminishes and its effectiveness lessens, the days would slowly warm and its need lessen as well. Building technology in seasonal harmony. DS

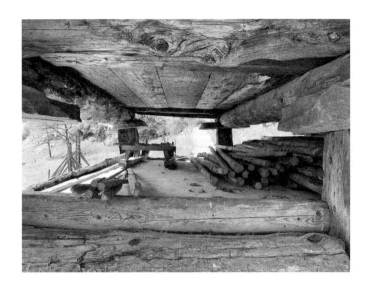

Keeps out the rain and lets in the wind to pass. Life is designed with rational purposes. TT

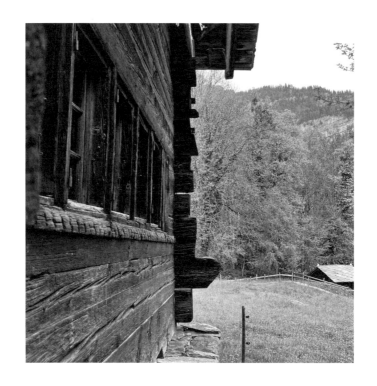

You see many things large and small, with an ease and grace about them, where the question of "how should this look?" – which is just another way of saying "how will this make me look?" – doesn't seem to be of great concern. They are not unfinished, careless or even particularly expedient; and it is unlikely that they are the product of rebelling against tradition or releasing repressed artistic desires. With no neighbors to impress and no gods to please or fear, this might just be the pure expression of freedom. DS

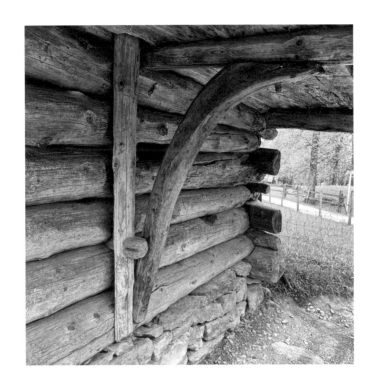

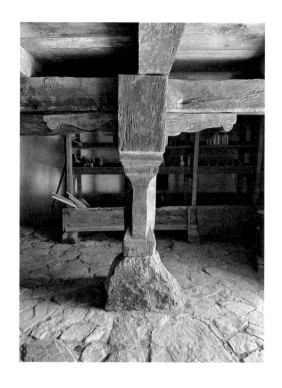

Structure as event. DS

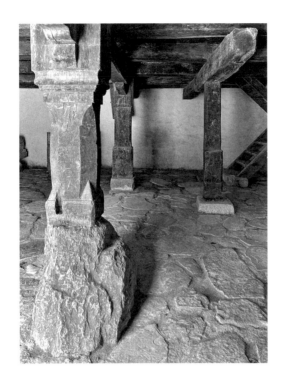

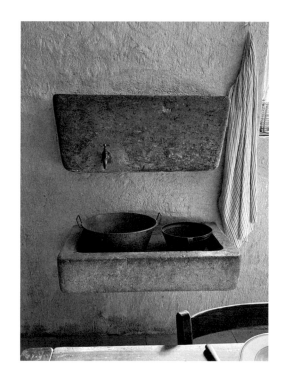

Something Roman about this arrangement. It took some time to realize that the matching stone above the sink with the tap on it must be the wall of a water tank. JM

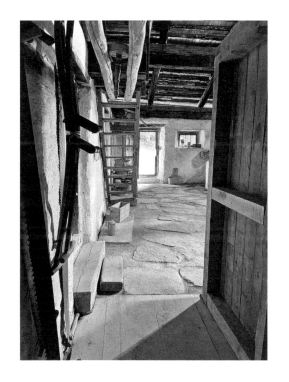

Flat stones set into an earth floor, like a multi-directional path. JM

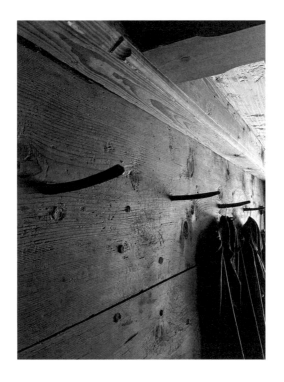

A quick and easy solution to the problem of where to keep your clothes, wooden sticks slanted to keep the hangers from sliding off. JM

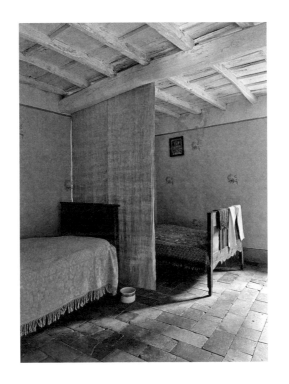

Some privacy better than none? JM

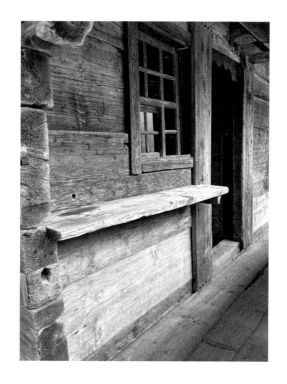

Adding a place to put something down next to the entrance of a building
is another in a growing list of things that should make their way from the rural
to the urban. DS

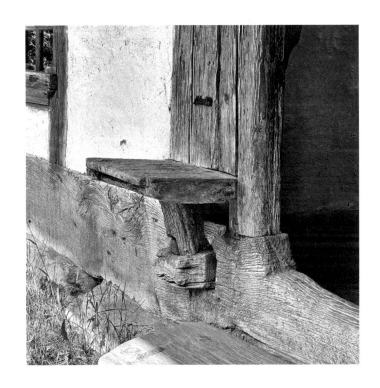

It is always nice to sit by the door of a house, and a rural dwelling is often complemented by a bench set near to it. This door features something even simpler: a stool. Good enough to sit down and put on or take off shoes, to support a bucket or a basket, to invite us to pause while dealing with any threshold in life. FZ

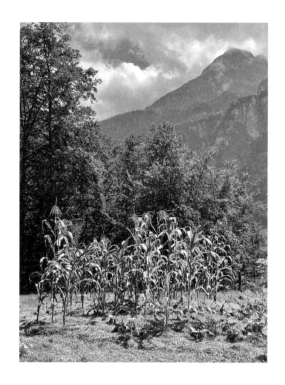

As any hiker knows, after a few hours walking in the mountains, coming across a small field of corn and then a house next to it is both a reassuring and satisfying break from the surroundings of nature doing its own thing. The corn is signpost to settlement and the atmosphere is instantly changed. The house without the corn, or any other crop, would be less welcoming; it suggests a peaceful self-sufficiency. Surrounded by the Swiss mountains, its South American heritage is as close as you'll get to exotic. JM

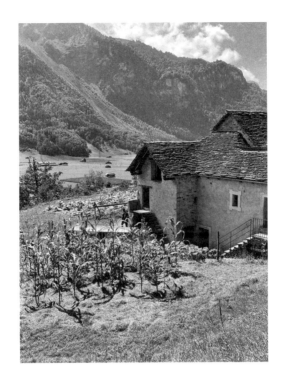

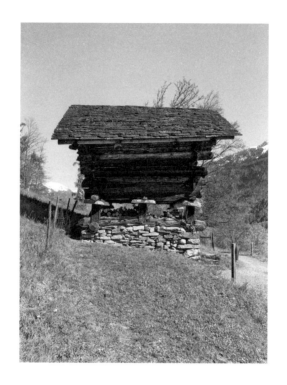

The wooden house sits on top of a stone one; there is something sublime about its primitive character. TT

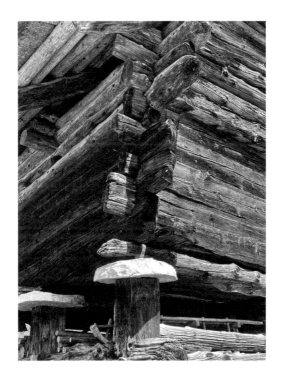

The construction of this log cabin makes it rigid enough to simply rest on the stones, which rest on the foundation posts, without any fixing other than the force of gravity. The stones keep out the mice and the damp. JM

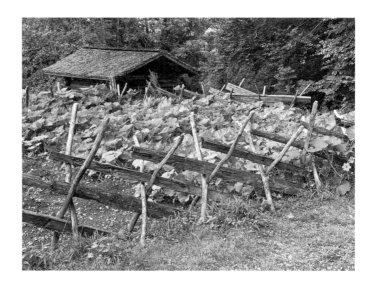

I admire the economy of this fence, each quartered length held in three places, on the ground, under the crossed supports and resting on top of the next pair. Quick and easy to make, using the least possible number of elements, and effective enough to keep the cows off the crops. JM

*Take an ax handle, for example. You wouldn't say that an ax handle has style to it. It has beauty, and appropriateness of form, and a "this-is-how-it-should-be-ness." But it has no style because it has no mistakes.*

Charles Eames

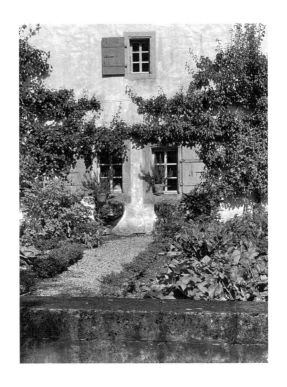

A low wall to keep the rabbits out, but no need for privacy. JM

# Today's Perspectives on Yesterday's Buildings

Beatrice Tobler

Open-air museums afford us glimpses of domestic landscapes, economies, and ways of life that no longer exist today in the same form. If you look closely, you can learn a lot about the past while gaining inspiration for the future and discovering possible solutions to the problems of the present.

Open-air museums are one of the most accessible and highly frequented types of museum. Based on thorough research, they bring together mainly rural residential and farm buildings that have been supplanted by subsequent development at their original location and are given a second home in the context of a museum.

The first European open-air museums were established in Scandinavia in the late nineteenth century in the course of a movement that set out to preserve the supposedly idyllic country life in the face of rampant industrialization. A wave of further museums then followed in the 1960s, when modern infrastructure and land-use planning further transformed the countryside, increasingly crowding out the built witnesses to rural culture.

# The Open-Air Museum on Ballenberg

Open-air museums thus sprang up all over Europe in the 1970s – including one in Switzerland that opened its doors in 1978 with twenty-six buildings. Located on Ballenberg, a hill near Brienz in the Bernese Oberland, the museum today encompasses 110 relocated rural residential and commercial buildings from all regions of the country, arranged across an area of sixty-six hectares. The oldest building dates back to 1336, the youngest to around 1900.

The way in which the buildings were reconstructed on Ballenberg reflects the standards of monument preservation and museology at the time of the respective relocations. Initially, they were rebuilt to represent an "original" and "typical" state. More recently, efforts have been made instead to reflect the gradual process by which they were constructed, making later additions visible.

To move the buildings, their components are numbered, dismantled, transported, and rebuilt on the museum grounds. They are placed there in a regionally and historically appropriate cultural landscape through the context of traditional crafts and agricultural activities.

These buildings of yesteryear can be viewed from different perspectives, including the research angle, which examines their components in order to identify, for example, different stages of construction. An extension to a building reveals an episode of social advancement. When a building is divided into several parts, this by contrast provides evidence of

a social setback. The addition of storehouses or stables tells of changing agricultural practices. By researching the history of the residents, a veritable biography of the house emerges. However, although research can compile facts and information, these fragments are always pieced together in the present moment. It is therefore today's point of view that creates a history out of the past, telling stories that are of interest to the people of today. This is the educational work carried out by the museum.

We are only ever able to see the buildings in the open-air museum with today's eyes. Former social circumstances, dependencies on authorities and environmental conditions, and the sheer physical effort it took to get through the year are factors we can only guess at. We may thus be tempted to frame the simple life we assume once took place here as a counter-pole to our stimulus-flooded world, similar to how people in the nineteenth century viewed seemingly unspoiled country life in the days of industrialization.

This is why it is worthwhile to explore at a leisurely pace the various building ensembles at the open-air museum on Ballenberg, which represent all major Swiss regions. In each region, people came up with different solutions to the same problems when building their homes, applying craft traditions to locally available materials and taking account of the topographical and climatic conditions.

A farmstead often included several plots of land and outbuildings. Covered arbors were used for drying crops or herbs. Forecourts

provided shelter from the weather for working outdoors,
in a transition area between the house and barn. The buildings
were constantly adapted to changing needs, converted,
and sometimes even moved. Within the village community,
many facilities were shared, such as mills, troughs, wash houses,
and of course the commons. The farmers supported the
craftsmen in construction activities, and neighbors helped
one another. If one farmer assisted another with wainwright work,
for example, he might then borrow the other's horse to run
his threshing machine.

Today, our houses are where we spend our free time. Covered
outdoor spaces are now associated with relatively new concepts,
such as a view, leisure, rest and relaxation. The way of life
in rural Switzerland in earlier centuries was thus very different
from ours today. And yet, some aspects can still serve as a
model for us.

Neighborly assistance and borrowing things from each other
are viable future strategies. Regionally available building materials
that stand up well to the local climate allow for short transport
distances and ensure the longevity of the structures. Besides
wood, the materials of clay and lime are likewise experiencing
a well-deserved revival in the building trade and interior
design. Using time-tested craft techniques such as sound
carpentry lays the foundation for buildings that are able
to adapt to their changing occupants. The radical transformation
made possible by recycling, conversion and repurposing is
evident in the open-air museum. This kind of flexibility is worth

regaining. We should understand architecture not as a one-time creation, but as an ongoing process.

As an incidental effect, the extensive operation of many open-air museums has contributed to preserving rich biodiversity. Cracks and openings in roofs, walls and floors offer habitats for insects, reptiles, birds and bats. In this way, too, the open-air museum can be a model for the design of our future living spaces and ways of life.

Index of buildings at Ballenberg, which were observed by the authors.

642 Row of Granaries
Tagelswangen / Lindau ZH, 1534 / 1661 / 1819
519 m a.s.l.

693 Wine Press
Schaffhausen SH, 15th Century / 1750
403 m a.s.l.

695 Public Works Barn
Aarau AG, 1711
384 m a.s.l.

711 Dwelling
Sachseln OW, around 1600 / 1850s
483 m a.s.l.

721 Dwelling
Erstfeld UR, 1730
475 m a.s.l.

723 Hay Barn
Spiringen UR, 19th Century
923 m a.s.l.

741 Farmhouse
Escholzmatt LU, 19th Century
852 m a.s.l.

751 Dwelling
Schwyz SZ, 1336
516 m a.s.l.

821 Dwelling
Malvaglia / Serravalle TI, 1515 / 1564
389 m a.s.l.

832 Granary
Campo / Campo Vallemaggia TI, 1515
1321 m a.s.l.

841 Residential Complex
Cugnasco TI, around 1740 / 1770 / 1860
225 m a.s.l.

842 House for Chesnut-Drying
Prato-Sornico / Lavizzara TI, 19th Century
750 m a.s.l.

851 Farmstead
Novazzano TI, 13th–19th Century
345 m a.s.l.

911 Farmhouse
Brülisau AI, 1621 / 1754
924 m a.s.l.

931 Dwelling
Wattwil SG, 1455 / 18th Century
610 m a.s.l.

1011 Farmhouse
Bonderlen / Adelboden BE, 1698
1350–1364 m a.s.l.

1012 Cheese Granary
Lütschental BE, early 17th Century
714 m a.s.l.

1022 Cheese Granary
Niederried BE, 1652
578 m a.s.l.

1024 Hay Barn
Brienzwiler BE, 19th Century
680 m a.s.l.

1031 Dwelling
Brienz BE
566 m a.s.l.

1051 Craftman's House with Pottery
Unterseen BE, 1800 / 1850
567 m a.s.l.

1061 Rope Walk
Unterägeri ZG, 1897
727 m a.s.l.

1111 Dwelling
Blatten VS, 1568
1542 m a.s.l.

1311 Alpine Hut
Champatsch / Val Müstair GR, 1825
2093 m a.s.l.

1341-45 Alpine Buildings
Richinen / Bellwald VS, first half 18th Century
1560–2064 m a.s.l.

1351 Alpine Hut
Axalp / Brienz BE, 1520
1535 m a.s.l.

1362 Cheese Granary
Leissigen BE, 1780
575 m a.s.l.

1371 "Maiensäss" House (Spring Camp House)
Buochs NW, 1722
435 m a.s.l.

Rolf Fehlbaum, born in Switzerland in 1941, studied social science and earned his PhD with a thesis on utopian socialism. Before becoming CEO and later chairman of Vitra, Fehlbaum was active in the production of art editions and documentary films and in architectural education. During his tenure at Vitra, he established relationships with many of the world's leading designers and architects and developed projects with Tadao Ando, Frank Gehry, Zaha Hadid, Nicholas Grimshaw, Álvaro Siza, Herzog & de Meuron and SANAA, all of whom designed buildings for the Vitra Campus in Weil am Rhein. An avid collector of twentieth-century furniture, Fehlbaum founded the Vitra Design Museum in 1989, which is now considered one of the foremost institutions in its field.

Jasper Morrison, born in London in 1959, is a British designer well known for his work in furniture, lighting, tableware and everyday products. He studied design at Kingston Polytechnic, the Royal College of Art and Berlin's HdK. In 1986 he opened his Office for Design in London, which remains his base. Morrison aims to design objects that sit naturally in a wide range of everyday situations. His approach to design is reflected in the book and exhibition *Super Normal*, which he organized in Tokyo in 2006 with the designer Naoto Fukasawa. He has published several books with Lars Müller Publishers, including *A World Without Words*, *The Good Life*, *A Book of Things* and *Super Normal* (with Naoto Fukasawa). He has curated and participated in many exhibitions in Japan, the USA and across Europe. His contribution to design has been recognized with a membership of the Royal Designers for Industry, a Commander of the British Empire award and the Italian Compasso d'Oro award for his life's work.

David Saik, born in 1965, was raised on a farm on the Canadian prairie near the village of Innisfree, Alberta. Following an undergraduate degree in arts at the University of Alberta, he completed his post graduate studies in architecture at the University of British Columbia. After working in New York, London and Basel, he founded his own studio in Berlin, working locally and internationally for private and institutional clients, including designing studios for the artists Jeff Wall and Steven Shearer, factory renovations and a live/work/event building conversion for Emeco chairs, shop and trade fair designs for Camper shoes, and architecture and color schemes for numerous exhibitions at museums such as the Schirn Kunsthalle Frankfurt, Kunstmuseen Krefeld and the Vitra Design Museum. He has also undertaken a long-term collaboration with the Berlinische Galerie – the City Museum of Berlin – adding new exhibition galleries, a bookstore, and education, meeting and archive spaces. Saik is a registered architect with the Architektenkammer Berlin.

Tsuyoshi Tane, born in Tokyo in 1979, is a Japanese architect based in Paris. He studied architecture at Hokkaido Tokai University and the Royal Academy of Art in Denmark. He founded ATTA – Atelier Tsuyoshi Tane Architects in Paris in 2017 after being co-founder of DGT Architects in 2006. He believes that architecture must belong to the memory of a place, based on the concept of "Archaeology of the Future." His major projects include the Estonian National Museum, Hirosaki Museum of Contemporary Art, The Al Thani Collection and Tane Garden House on the Vitra Campus. He is currently designing the Imperial Hotel in Tokyo (to be completed in 2036). Tane has received numerous awards, including the Grand Prix AFEX 2016 and 2021, the Jean-Dejean Prize of the French Académie d'Architecture and the 67th Japanese Ministry of Education New Face Award for Fine Arts. He published his first monograph, *Tsuyoshi Tane: Archaeology of the Future*, in 2018.

Beatrice Tobler, born in 1967, studied folklore/European ethnology, art history and Latin philology in Basel. From 1996 to 1999, she was a research assistant at the University of Basel, and from 1999 to 2012 curator for communication technologies and digital culture at the Museum of Communication in Bern. She was director of research and deputy managing director at the Open-Air Museum Ballenberg from 2012 to 2022. Since 2022 she has been curator for history and exhibitions and a member of the executive board at the Museum Luzern.

Federica Zanco, born in Italy in 1961, studied architecture at the Istituto Universitario di Architettura di Venezia (IUAV) in Italy. She has a PhD in architecture and was on the editorial staff of the *Ottagono* and *Domus* magazines. She has been director of the Barragan Foundation, Switzerland, since 1996.

Sources

27  Bo Bardi, Lina. In *Lina Por Escrito*, edited by Marina Grinover and Silvana Rubino. São Paolo: Cosac Naify, 2009. © Instituto Bardi / Casa de Vidro.

45  De Silva, Minnette. *The Life & Work of an Asian Woman Architect*. Colombo: Smart Media Productions (Pvt) Ltd., 1998.

54  Perriand, Charlotte. In Adler, Laure. *Charlotte Perriand*. Paris: Éditions Gallimard, 2019. © 2023, ProLitteris, Zurich.

57, 102  Rudofksy, Bernard. *Architecture without Architects*. New York: Museum of Modern Art, 1964. © The Bernard Rudofsky Estate Vienna / 2023, ProLitteris, Zurich.

71  Perriand, Charlotte. "L'habitation familiale, son développement économique et social." *L'Architecture d'Aujourd'hui*, January 1935, 25–32. © 2023, ProLitteris, Zurich.

87, 191  Eames, Charles. In *An Eames Anthology*, edited by Daniel Ostroff. New Haven and London: Yale University Press, 2015. © Eames Office LLC (eamesoffice.com). All rights reserved.

110, 172  Fathy, Hassan. *Architecture for the Poor: An Experiment in Rural Egypt*. Chicago and London: University of Chicago Press, 1973. Used with permission of the University of Chicago Press – Books. Permission conveyed through Copyright Clearance Center.

121, 138  Alexander, Christopher. *The Nature of Order: An Essay on the Art of Building and the Nature of the Universe – Book One: The Phenomen of Life*. Berkeley, CA: Center for Environmental Structure, 2002. Courtesy of Christopher Alexander and the Center for Environmental Structure.

154  Moholy-Nagy, Sibyl. *Native Genius in Anonymous Architecture*. New York: Horizon Press Inc., 1957. © 2023, ProLitteris, Zurich.

The quotes in this book are from influential thinkers and creators of the twentieth century. In the midst of the modern age, they were alert to the importance of the knowledge of traditional forms and techniques for responsible building and a humane environment.

**Christopher Alexander** 1936–2022
The Austrian-born British-American architect, architectural theorist and systems designer was influential beyond architecture. He taught at the University of California, Berkeley from 1958 to 2002.

**Lina Bo Bardi** 1914–1992
The Italian-born Brazilian architect and editor devoted her prolific working life to promoting the social and cultural potential of architecture and design.

**Minnette de Silva** 1918–1998
The Sri Lankan architect and editor experimented with indigenous methods and materials in her practice and promoted a regional approach to modern architecture.

**Charles Eames** 1907–1978
The American designer and architect is remembered for his sleek and functional furniture designs developed in close collaboration with his wife and partner, Ray Eames.

**Hassan Fathy** 1900–1989
The Egyptian architect embraced vernacular techniques, forms and materials as part of a lifelong campaign to improve the living conditions of the rural poor.

**Sibyl Moholy-Nagy** 1903–1971
The German-born American art historian and architectural critic played an important role in the reassessment of modern architecture in the USA after World War II.

**Charlotte Perriand** 1903–1999
The French architect and designer believed in the power of good design to enable affordable, humane living spaces for a better and more equal society.

**Bernard Rudofsky** 1905–1988
The Austrian-American writer, architect and teacher advocated an expanded notion of architecture with emphasis on vernacular, indigenous and anonymous architecture.

you look, but do you see?

Patient and curious looking is the prerequisite for seeing.
Associations are awakened and the image settles in memory.

The aim of this book is to inspire us to discover past worlds lying far away from our own everyday lives. Closer inspection reveals treasures which remind us that clever and lasting solutions to mundane problems can be found with modest means, without sacrificing beauty or atmosphere.

The editor and the authors of this book hope to encourage readers to renounce trends and fashions and to meet the challenges of our time with attention to the real and the existing, to the useful and the enduring.

Lars Müller

A Way of Life
Notes on Ballenberg

Edited by Rolf Fehlbaum
Notes and photographs by Jasper Morrison, David Saik,
Tsuyoshi Tane, Federica Zanco
With a contribution by Beatrice Tobler

Editorial advice: Lars Müller
Editorial coordination: Fanny Rakeseder, Hester van den Bold
Translation and proofreading: Jennifer Taylor
Copyediting: Catherine Schelbert
Design: Integral Lars Müller/Lars Müller with Semaya Mehret
Production and typographic editing: Esther Butterworth
Lithography: prints professional, Berlin, Germany
Printing and binding: DZA Druckerei zu Altenburg, Germany
Paper: Munken Lynx, 130 g/m²

Lars Müller Publishers
Zurich, Switzerland
www.lars-mueller-publishers.com

ISBN 978-3-03778-726-7

Distributed in North America, Latin America and the Caribbean
by ARTBOOK | D.A.P.

www.artbook.com

Printed in Germany